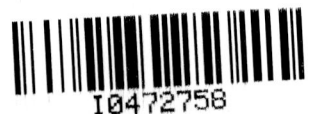

ROBERT EDSEL
and
THE MONUMENTS MEN

Presented to the '81 Club

Monday 20 January 2014

by **Mrs. Alan R. Marsh**

Text @ 2015 by JOAN'S eBOOKS LLC

All rights reserved. No part of this Kindle Edition or Paperback text may be reproduced in any form without permission in writing from JOAN'S eBOOKS LLC except by a newspaper or magazine or on-line reviewer who wishes to quote brief passages in a review.

ISBN: 9781520976853

Contact Joan Marsh at email: joanmarsh@aol.com

JOAN'S THRILLING READING LIVING VICARIOUSLY Series
https://www.ebooksbyjoanmarsh.com/

JOAN'S CHARACTER EDUCATION PICTURE BOOKS for CHILDREN Series
https://www.childrensebooksbyjoan.com

JOAN'S AMAZON AUTHOR PAGE
https://www.amazon.com/author/joanmarsh

JOAN'S FACEBOOK PAGE and TWITTER ACCOUNT
https://www.facebook.com/people/Joan-K-Marsh/100011486057355
https://www.twitter.com/@joanmarsh3

Book Interior Design & eBook conversion by manuscript2ebook.com

Volume Number Ten

The THRILLING READING LIVING VICARIOUSLY Series

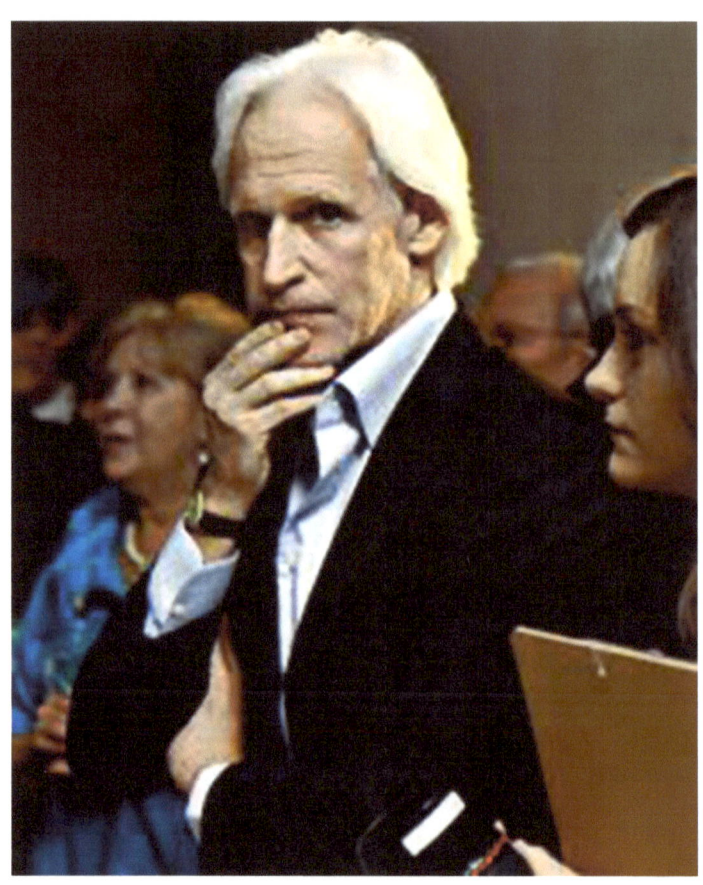

Robert Edsel

ROBERT EDSEL and THE MONUMENTS MEN

Presented to the '81 Club Monday 20 January 2014
by **Mrs. Alan R. Marsh**

To begin, we have Robert M. Edsel. He is the modern man who has single handedly put the Monuments Men back on the map, so to speak. He is the author of several books about the work of the Monuments Men,

such as *RESCUING DA VINCI: Hitler and the Nazis Stole Europe's Great Art – America and her Allies Recovered It*, published in 2006 and

THE MONUMENTS MEN: Allied Heroes, Nazi Thieves and the Greatest Treasure Hunt in History, published in 2010 and

SAVING ITALY: The Race to Rescue a Nation's Treasures from the Nazis, published in early 2013. In fact he was here in Kansas City just last spring as a guest of Rainy Day Books promoting this book.

And his most recent book is *ROSE VALLAND: Resistance at the Museum*, published in October 2013. Remember Rose's name…she is really Cate Blanchett.

Mr. Edsel's forthcoming movie *THE MONUMENTS MEN* is based on the 2010 book mentioned above. It was due to be released this December just in time for the Academy Awards, but at the last minute the producer George Clooney declared that some of the special effects were just too "cheesy" for his movie and they simply didn't have enough skilled people to bring it in on time.

So they re-scheduled the film, co-produced by Columbia Pictures/20th Century Fox and Babelsberg Studio, to be released on 7 February 2014 which of course is just around the corner.

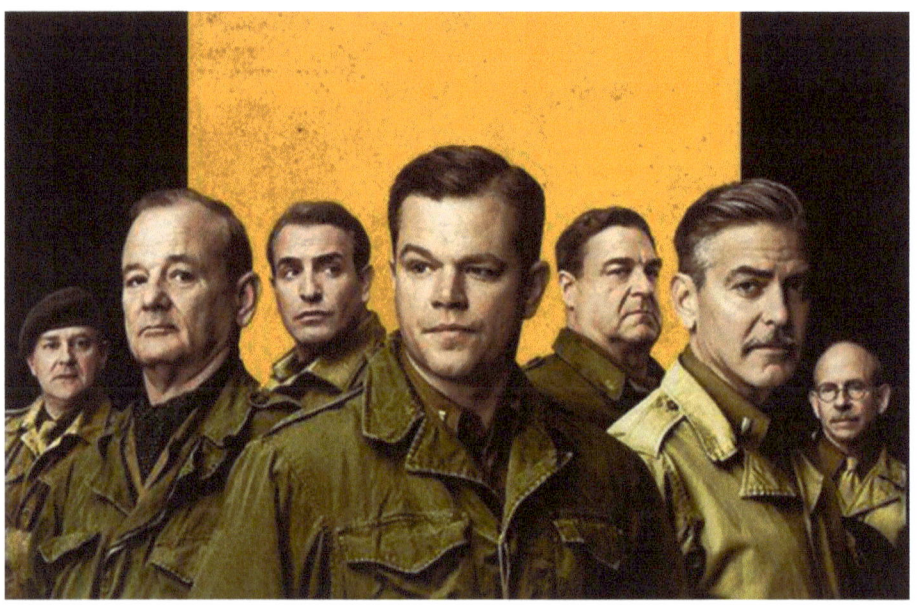

The Monuments Men Poster

To whet our appetites, please note that the cast includes George Clooney, Matt Damon, Bill Murray, John Goodman, Jean Dujardin (of *The Artist* fame) Bob Balaban, Hugh Bonneville (of *Downton Abbey* fame) and last but not least, Cate Blanchett in the role of Rose Valland.

More about the movie:

Based on fact, the film focuses on an Allied platoon made up of seven museum directors, curators, and art historians, tasked with going into Germany in the closing stages of World War II to rescue artworks requisitioned by the Nazis and returning them to their rightful owners.

Principal photography began in early March 2013 at the Babelsberg Studios in Potsdam, Germany, and in the Berlin-Brandenburg region and the Harz, where the City of Osterwieck was a particularly important place for the outdoor scenes. A cast of thousands was needed for the military scenes. Some of the scenes, including flights and American war base footage, were filmed at the Imperial War Museum Duxford, Cambridgeshire UK. Filming was scheduled to last until the end of June 2013, wrapping up in Rye, East Sussex.

So to learn more about this Robert M. Edsel, the person who set all this activity in motion...

He was born in 1956 in Oak Park, Illinois, and raised in Dallas, Texas. He is the son of Norma Louise (a housewife) and Alpha Ray Edsel (a stockbroker). At one time, he was a nationally ranked tennis player.

In 1981 Robert Edsel began his business career in oil and gas exploration...in Texas, one would think. His company, Gemini Exploration, pioneered the use of horizontal drilling technology

throughout the early 1990s. Gemini Exploration grew from a company with eight employees to almost 100.

By 1995, Gemini had become the second most active driller of horizontal wells in the United States and Robert Edsel sold the company's assets to Union Pacific Resources Company.

So that answers the question of "Where did he and his wealth come from?" and the next question of course would be "What led him to the Monuments Men?"

That is a more burning and complicated question. The more I read about Mr. Edsel's life after 1995, the more the picture emerges of a suddenly enormously wealthy man with time to spare and money to burn…who had the brains and the interests to seek a truly original and gratifying and useful way to spend that time and money…a wonderful example of what wealth can be used to accomplish in the hands of a thoughtful person. We don't know anything about his personal character, but have to admire his dedication to historical preservation and research and the Monuments Men. Clearly, he is a man entranced with this work.

In 1996, Robert Edsel moved to Europe with his family. While living in Florence, Italy, in the heart of the country responsible for so much that is beautiful and fine in the art world, he began to think about the methods and planning used to keep art out of the hands of Adolf Hitler and away from Nazi Germany. No wonder he started thinking about this. Even today remnants of Mussolini's regime are still so evident in Rome, Florence and other parts of Italy.

Following a divorce in 2000, as night follows the day, Robert Edsel moved to New York City, where he began a serious effort to learn about and understand the issue of the lost art.

By 2004, those efforts had become a full time career, and he established a research office in Dallas, his home town. By 2005, he had gathered thousands of photographs and other documents, and began writing the manuscript for his first book, *RESCUING DA VINCI*. This book received wide attention.

In September 2009, his second book, *THE MONUMENTS MEN*, a narrative telling of the story of the Monuments Men, was released by Hachette Book Group. Plans included publication of that book in seventeen languages.

These books were followed, as we know, by the two other titles mentioned earlier.

While this was going on, Mr. Edsel co-produced a documentary film, *The Rape of Europa*, based on a book by Lynn Nicholas. Narrated by Joan Allen and well received by critics, the film began a theatrical run in September 2007 at the Paris Theatre in New York City.

In the meantime, not to waste a second, he created *The Greatest Theft in History*, an educational program, which includes the documentary film *The Rape of Europa* as well as seven hours of additional clips, a companion website featuring lesson plans, glossaries, timelines and other resources which allows teachers to use this material for classroom teaching.

Again, and most importantly, while all this was going on, Mr. Edsel created the Monuments Men Foundation for the Preservation of Art.

The Foundation's mission is "to preserve the legacy of the unprecedented and heroic work of the men and women who served in the Monuments, Fine Arts, and Archives section, known as 'Monuments Men' during World War II, by raising public awareness of the importance of protecting and safeguarding civilization's most important artistic and cultural treasures from armed conflict."

He announced the Foundation's creation during a ceremony at The White House on 6 June 2007, the 63rd anniversary of D-Day.

Then…there are the Nazi albums.

During the course of his research into the whereabouts of lost art and the efforts to save it, Edsel discovered the existence of two large, leather-bound photograph albums which documented portions of the European art looted by the Nazis. The two albums were in the possession of the heirs of an American soldier who was stationed in the Berchtesgaden area of Germany in the closing days of World War II.

The albums were created by the staff of the Third Reich's Einsatzstab Reichsleiter Rosenberg (more comfortably known as the ERR), a special unit that found and confiscated the best material in Nazi-occupied countries. In France, the ERR engaged in an extensive and elaborate art looting operation, part of Hitler's much larger premeditated scheme to steal art treasures from conquered nations. The albums were created for Hitler and high-level Nazi officials as a catalog to give Hitler a way to choose the art for his own museum in Austria. A group of these photograph albums was presented to Hitler on his birthday in 1943. Nearly 100 albums were created during the years of their art looting operation. We do not know what happened to the other 98.

These must have been amazing albums, and only the two Edsel albums are known to have survived the war. Robert Edsel worked with the owners of the two albums to acquire them for preservation. In November 2007, at another ceremony at the White House with the Archivist of the United States, Robert Edsel announced the existence of these albums to the public, as well as his donation of the albums to the National Archives.

National Archivist Allen Weinstein called the discovery "one of the most significant finds related to Hitler's premeditated theft of art and other cultural treasures to be found since the Nuremberg trials."

So in summary, these extraordinary measures taken by Robert Edsel very much put The Monuments Men on the map for the current generation. The photos in the books are fascinating and are information for a whole new generation of Americans.

Personally, I would like to point out the inclusion of the Amber Room, which was an earlier '81 topic.

One of the iconic da Vinci paintings, *Lady With an Ermine* (our cover girl, the portrait of Cecilia Gallerani) is reminiscent of and frequently mentioned in the same breath with the painting *La Belle Ferronniere*. The authenticity of *La Belle Ferronniere* as a painting by Leonardo da Vinci was disputed in an infamous 1929 court case. According to information provided by Sotheby's where it was auctioned about four years ago, the work was likely painted by a French artist in the seventeenth century.

It's impossible not to diverge here with the story of *La Belle Ferronniere*. We can justify this detour because at the end of the day it is the story of another piece of misplaced art as a result of another war, World War I, and more intriguingly, has surprising Kansas City connections.

In 1919 a returning World War I veteran named Harry Hahn and his French war bride attempted to sell what they thought was a painting by Leonardo da Vinci in New York. The renowned art dealer, Sir Joseph Duveen declared the picture – *La Belle Ferronniere* – a fake without ever seeing the canvas. The Hahns sued Duveen for slander, setting off a legal battle that would last for decades, in the course of which art authentication was forever changed. But that is another paper.

The fun part of the Hahn story is the back story about Harry Hahn himself. In 1917 he enlisted in the army, serving first in Texas and then in France. Although he boasted that he was a highly decorated captain and an aviator, there is reason to suppose he was actually a sergeant and a mechanic. In 1919 he married a French girl named Andree Ladoux, who lived with her godmother, Josephine Massot, a milliner.

One of Josephine's friends was an eccentric woman of dubious aristocracy named Louise de Montaut, whom Andree called her "aunt."

La Belle Ferronniere

Mme de Montaut possessed a painting that she had always been told was by Leonardo da Vinci, and when Andree and Harry Hahn got married on 12 July 1919, she – amazingly – gave them this picture of potentially immense value as a wedding present. Although there is some reason to doubt that she ever actually gave it to the Hahns as a gift. From this point, the "facts" become even more tangled, and are very likely part truth and part myth.

Anyway, *La Belle Ferronniere* was brought to America, not by the Hahns when they returned to Junction City, Kansas, in 1919, where Harry became a car salesman, but by Mme de Montaut who arrived in New York June 1920. Even before the Hahns left France they had begun to make efforts to sell the painting in the United States.

Only three days after Mme de Montaut and the painting arrived in America, Joseph Duveen received that famous early morning phone call from a reporter at the *New York World* who asked his opinion of the painting that had been offered to the Kansas City Art Institute for something like $250,000. Although he had never seen the Hahn picture, Duveen did not hesitate to declare it a fake, pointing out that the original was, after all, in the Louvre, and so this could be ONLY a copy.

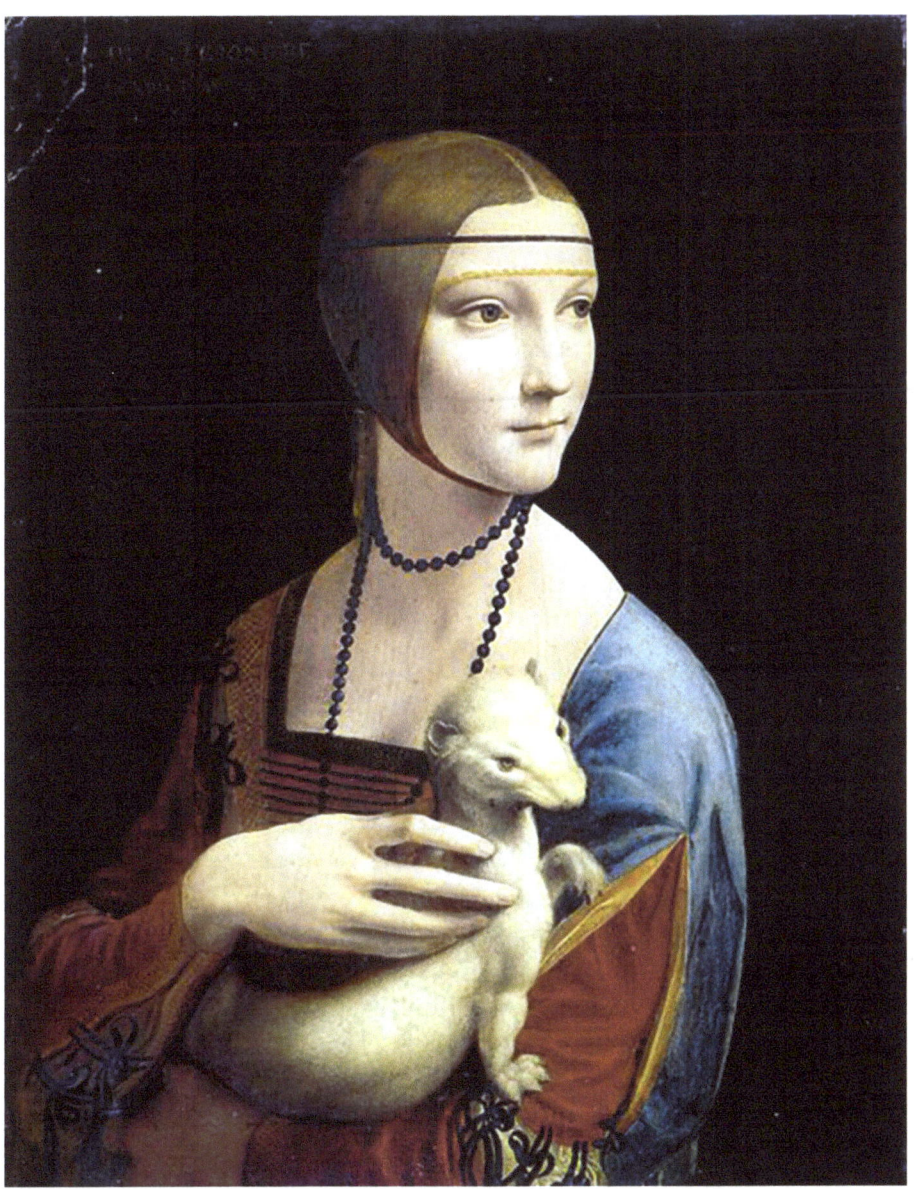

The Lady with an Ermine

The painting in the Louvre is a late 15th century portrait of a woman thought to be Lucrezia Crivelli, mistress of the Duke of Milan, or possibly his wife. Another of his mistresses, Cecilia Gallerani, is depicted by Leonardo as the *Lady with an Ermine.*

We have seen this very painting being rescued on the cover of *RESCUING DA VINCI.*

What a tangle. So the lawsuit between Duveen and the Hahns went on for years. By 1996 there were 29 leins worth almost $42 million on the painting. And this book, by John Brewer, has so much suffocating detail…Suffice it to say the names of Frank Glenn and Thomas Hart Benton are also part of the Kansas City story.

At the end of the day, amidst and as the result of all the intervening squabbling, the painting *La Belle Ferronniere* was auctioned at Sotheby's in New York City on 28 January 2010. There was lots of press surrounding the auction. According to Sotheby's catalog, "recent technical examination of the infamous portrait including pigment analysis, indicates that the Hahn painting dates from the seventeenth century… thus confirming a previous scholarly opinion that it was not by Leonardo…although it might possibly have been painted by the French baroque painter Laurent de la Hyre."

The presale estimate was $300,000-$500,000, and it actually sold at auction for $1,300,000 to an anonymous American private collector. Alan and I were among the many people who wanted to see it…and I will say it is a beautiful painting .

And so our detour ends…its back to The Monuments Men.

In 1943 the Monuments, Fine Arts, and Archives (MFAA) program was established by the Civil Affairs and Military Government Sections of the Allied armies to help protect cultural property in war areas during and after World War II.

This group of about 400 service members and civilians worked with military forces to safeguard historic and cultural monuments from war damage and, as the conflict of WW II came to a close, to find and return works of art and other items of cultural importance that had been stolen by the Nazis or hidden for safekeeping.

Many of the men and women of the MFAA went on to have prolific careers. Largely art historians and museum personnel, they had formative roles in the growth of many of the United States' greatest cultural institutions.

But even before the U.S. entered World War II, art professionals and organizations were working to identify and protect European art and monuments in danger of Nazi plundering. Commonly referred to as the Roberts Commission, this early group was dissolved in June 1946 when the State Department took over with the formation of the MFAA.

General Dwight D. Eisenhower facilitated the work of the MFAA by forbidding looting, destruction, and billeting (or camping out) in structures of cultural significance. He also repeatedly ordered his forces to assist the MFAA as much as possible.

This was the first time in history an army attempted to fight a war and at the same time reduce damage to cultural monuments and property.

"Prior to this war, no army had thought of protecting the monuments of the country in which and with which it was at war, and there were no precedents to follow…All this was changed by a general order issued by Supreme Commander-in-Chief Eisenhower just before he left Algiers, an order accompanied by a personal letter to all Commanders…the good name of the Army depended in great measure on the respect which it showed to the art heritage of the modern world."

As Allied Forces made their way through Europe, liberating Nazi-occupied territories, Monuments Men were present in very small numbers at the front lines. Lacking handbooks, resources, or supervision, this initial handful of officers relied on their museum training and overall resourcefulness to perform their tasks.

There was no established precedent for what they confronted. They worked in the field and were also actively involved in battle preparations. In preparing to take Florence, for example, which was used by the Nazis as a supply distribution center due to its central location in Italy, Allied troops relied on aerial photographs provided by the MFAA which were marked with monuments of cultural importance so that pilots could avoid damaging such sites during bombings.

When damage did occur, MFAA personnel worked to assess the damage and buy time for the eventual restoration work that would follow. Monuments officer Deane Keller had a prominent role in saving the Campo Santo in Pisa after a mortar round started a fire that melted the lead roof, which then bled down the iconic 14th century fresco-covered walls.

Keller led a team of Italian and American troops and restorers in recovering the remaining fragments of the frescoes and in building a temporary roof to protect the structure from further damage.

Restoration of those frescoes continues even today.

Frequently entering liberated towns and cities ahead of ground troops, Monuments Men worked quickly to assess damage and make temporary repairs before moving on with Allied Armies as they conquered Nazi territory.

American and Allied Forces discovered hidden caches of priceless treasures, many of which had been looted by Adolf Hitler and the Nazis, while others had been legitimately evacuated from German, French or Italian museums for safekeeping. Monuments Men oversaw the safeguarding, cataloguing, removal and packing of all works, regardless of their origin.

In Italy, museum officials had evacuated their holdings to various countryside locations such as the Tuscan villa of Montegufoni, which housed some of the Florentine collections. Here we see U.S. soldiers recovering priceless Italian art.

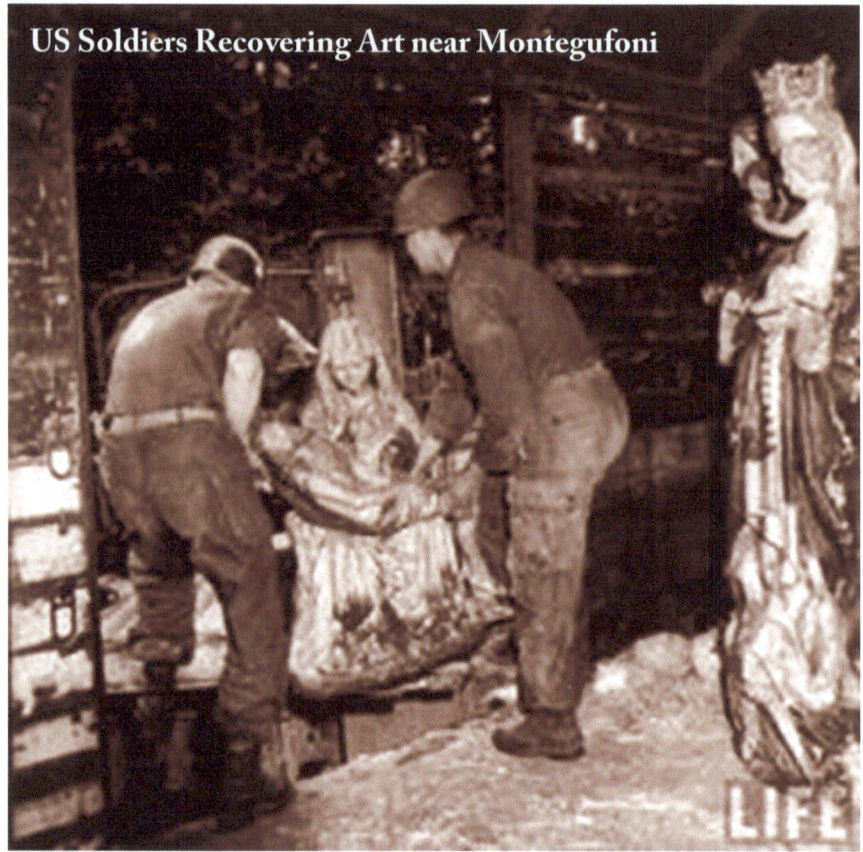

US Soldiers Recovering Art near Montegufoni

As Allied Forces advanced through Italy, the German army retreated north, stealing paintings and sculptures as they fled. As German forces neared the Austrian border, they were forced to store most of their loot in various hiding places such as a castle at Sand in Taufers and a jail cell in San Leonardo.

Beginning in late March 1945, Allied forces began discovering these hidden repositories in what would become the greatest treasure hunt in history. In Germany alone, US forces found about 1,500 repositories that contained art and cultural objects looted from institutions and

individuals across Europe, as well as from German and Austrian museum collections.

Some repositories of special note were:

Berchtesgaden, Germany – 1,000 paintings and sculptures stolen by Hermann Goring. The cache had been evacuated from his country estate, Carinhall, and moved in 1945 to protect it from invading Russian troops.

Bernterode, Germany – Four coffins containing the remains of Germany's greatest leaders including Frederick the Great and Field Marshal Paul Von Hindenburg were recovered.

Merkers, Germany – General George Patton in April 1945 found Reichsbank gold, along with 400 paintings and other crates of treasure. More dismal discoveries included gold and personal belongings from Nazi concentration camp victims.

Altaussee, Austria – This extensive complex of salt mines served as a huge repository for stolen art including Vermeer's *The Astronomer* and *The Art of Painting*, and paintings from the Capodimonte Museum in Naples stolen by Hermann Goring.

San Leonardo, Italy – In the jail cell of this very northern town Allied officials discovered paintings from the Uffizi that had been hurriedly unloaded by retreating German troops…paintings by Botticelli, Filippo Lippi and Giovanni Bellini.

This is a very superficial listing, and the scope of the project truly defies imagination.

By July 1945, US forces had established three central collecting points within the US Zone in Germany, and American organizational skills started to take over.

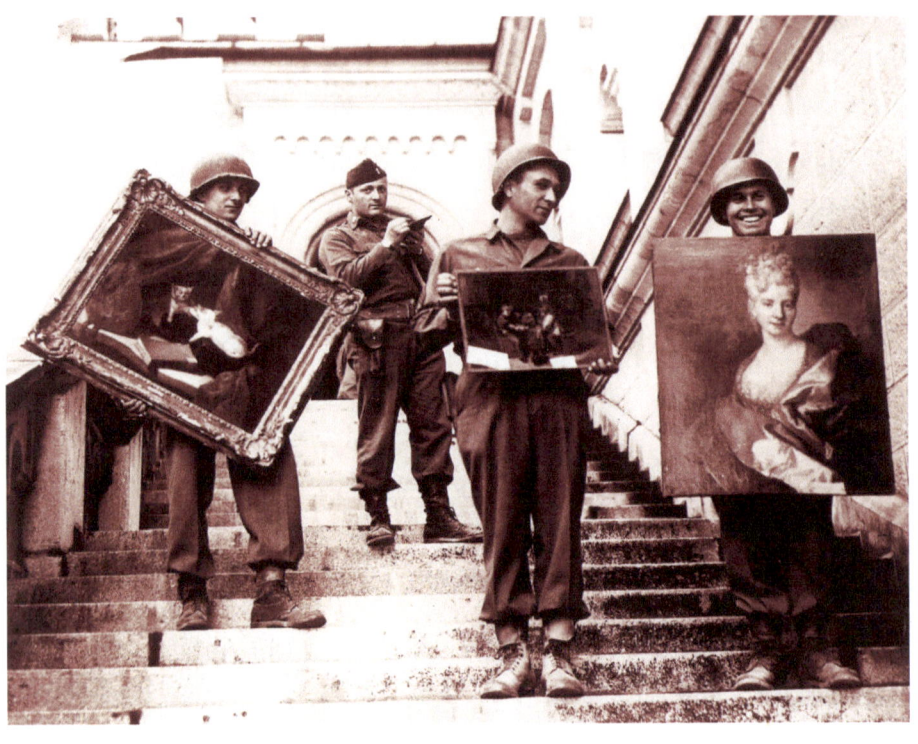

This is distinguished MFAA Officer James Rorimer supervising U.S. soldiers recovering looted paintings from Neuschwanstein Castle.

The first director of the collecting points, Captain Walter Farmer, and 35 others who were in charge of the Wiesbaden collection point, were compelled to draw up what has become known as the "Wiesbaden Manifesto" on 7 November 1945 declaring **"We wish to state that, from our own knowledge, no historical grievance will rankle so long or be the cause of so much justified bitterness as the removal for any**

reason of a part of the heritage of any nation even if that heritage may be interpreted as a prize of war."

Among the co-signers was Lt. Charles Percy Parkhurst of the US Navy.

Regarding the occupation of Japan, as the war neared its end in Japan in 1945, George Stout and fellow Monuments Man Major Laurence Sickman recommended creating an MFAA division in Japan. Consequently the Arts and Monuments Division …of the Allied Powers in Tokyo was established.

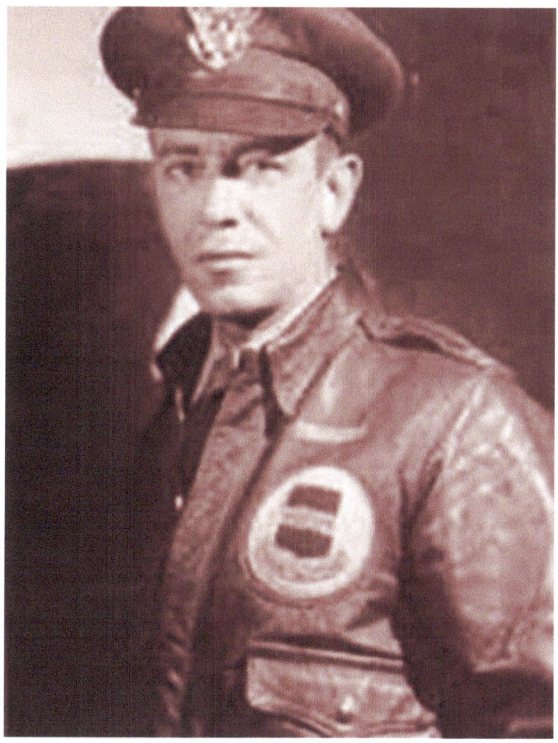

Laurence Sickman

Langdon Warner, archaeologist and curator of Oriental art at Harvard's Fogg Museum, and early mentor of Laurence Sickman, advised the MFAA Section in Japan until September 1946. This is important to Kansas City as Laurence Sickman went on to become the esteemed Director of the Nelson-Atkins Museum of Art.

To sum it all up, the American museum establishment led the efforts to create the MFAA section both in Europe and Japan. Included in this group were current museum directors, curators and art historians, as well as those **who wanted to be** museum directors, curators and art historians.

Upon returning home from service overseas, these men and women led the creation or improvement of some of the leading cultural institutions in the US. Many major museums employed one or more MFAA officers before or after the war, including the National Gallery of Art, the Metropolitan Museum of Art, the Museum of Modern Art, and the Nelson-Atkins Museum of Art.

Many other Monuments Men were professors at esteemed universities such as Harvard, Yale, Princeton, New York University, Williams College and Columbia University, among others. Paul J. Sachs' famous "Museum Course" at Harvard educated dozens of future museum personnel. S. Lane Faison's passion for art history was passed on to hundreds of students and future museum leaders at Williams College in the 1960s and 1970s, some of whom are currently directors at major US museums.

Other MFAA personnel became founders, presidents, and members of cultural institutions such as the New York City Ballet, the American Association of Museums, the American Association of Museum

Directors, the Archaeological Institute of America, the Society of Architectural Historians, the American Society of Landscape Architects, and the National Endowment for the Humanities and the National Endowment for the Arts, as well as respected artists, architects, musicians and archivists.

Two Monuments Men officers were killed in Europe, both near the front lines of the Allied advance into Germany.

They were Captain Walter Huchthausen, an American scholar and architect attached to the US 9^{th} Army, killed in April 1945 by small arms fire somewhere north of Essen and east of Aachen, Germany

and Major Ronald Edmund Balfour, a British scholar attached to the Canadian First Army, killed in March 1945 by an explosion in Cleves, Germany.

May they rest in peace.

THE END

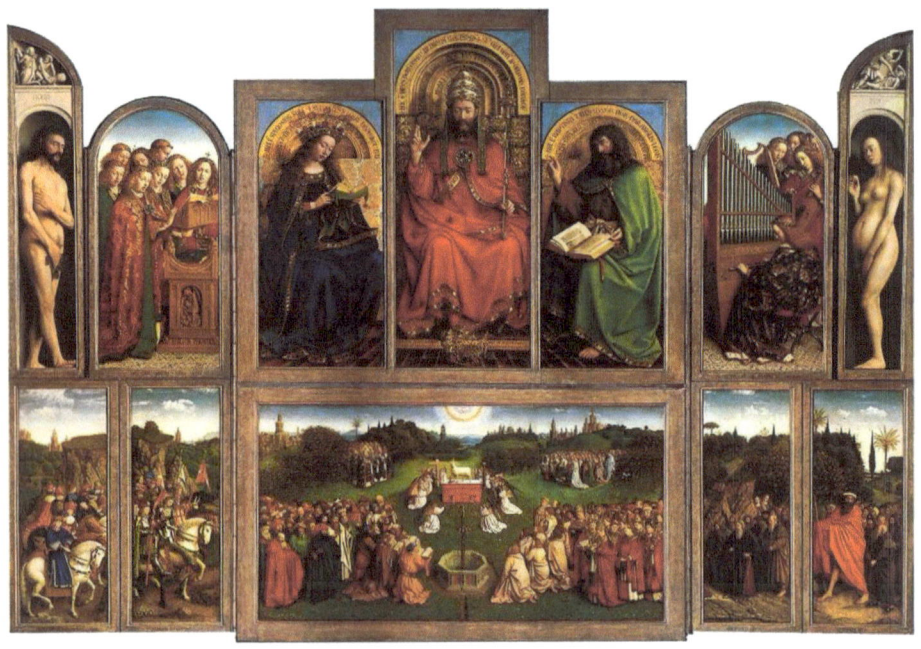

The Ghent Altarpiece

ABOUT THE AUTHOR

Joan Marsh is a member of the '81 Club of Kansas City, Missouri, which was formed in 1881 for the purpose of presenting scholarly papers to the membership, avoiding the forbidden topics of the Civil War, politics and religion. This compelling look at the creating of THE MONUMENTS MEN as researched by ROBERT EDSEL is one of many '81 Club papers spotlighting such stars as Madame Curie, Madame Chiang Kai-shek, Edna St. Vincent Millay, Nora Ephron, Isabella Stewart Gardner, David Douglas Duncan, Alfred Loomis, eventually totaling a body of work of 25 titles, better known as

The THRILLING READING LIVING VICARIOUSLY Series.

If 25 is the magic number for publications by Joan Marsh, then please skip ahead for a complete listing of the 25 exquisite children's books that form the nucleus of her life's work as a publisher, the.

CHARACTER EDUCATION PICTURE BOOKS for CHILDREN Series.

Joan attended the University of Missouri and holds a B.A. from Texas Tech University. Her major was English, and as night follows the day, led to her 43 year career in publishing education programs for children. Joan and Alan Marsh founded MarshFilm Enterprises, Inc. dba MarshMedia in 1969. The Marshes live in Kansas City, Missouri, where they raised their two sons. Those sons and their families, including eight grandchildren, who live all over the world, were the inspiration for many of the childrens' stories.

The family motto is *Carpe Diem.* Seize the Day!

THRILLING READING
LIVING VICARIOUSLY SERIES
Kindle Edition and Paperback

POETRY REVISITED EDNA ST. VINCENT MILLAY (Volume 1)
https://amzn.com/B0143UTP2Q

Be the first to rediscover the distinguished and celebrated American poet Edna St. Vincent Millay, whose lines

> *"My candle burns at both ends.*
> *It cannot last the night.*
> *But ah my foes and oh, my friends,*
> *It gives a lovely light"*

are still burning today with the same lyrical urgency

Not suitable for children, catnip for adults

Read this slim volume for a quick pickmeup while traveling abroad.

> *"Dark brown is the river,*
> *Golden is the sand"*
> *for the little children*

Edna makes her debut moving into the 21st century as fresh and saucy as ever!

THE SEARCH FOR FOREVER AMBER *(Volume 2)*
https://amzn.com/B014LRVMX6

A mini course in Russian history, amber history, Monuments Men, and the continuing mystery of what actually happened to the original Amber Room in the throes of World War II. All news to the casual observer.

The Mystery unfolds...

While traveling with the Met along the Baltic's Amber Coast en route to St. Petersburg aboard Sea Cloud II use this mini volume white paper to prep yourself on the story of "Amber."

Even though one wag said to me "Well, Amber is just pine sap, you know," I have to say it is so so much more than pine sap!

Today, stepping inside the Amber Room in the Catherine Palace museum is like slipping into a fairy tale – it's an Aladdin's cave!

Discover for yourself the breathtaking beauty of glowing amber, cut and polished, coming to the light from its lumpy, dark, rough birth.

But as with many fairy tales, especially Russian ones, there is a dark side to the Amber Room too, a shadow of legend and open-ended mystery.

And so we embark together on the search for forever Amber.

MARGARET QUEEN OF SCOTLAND *(Volume 3)*
https://amzn.com/B014V0MJGC

For all the precious Margarets in your family…

This compelling story about the incredible Medieval Queen Margaret is just in time for wonderful spring, summer, fall or winter reading. What better than to meet this modern feminist living in the 11th century.

Margaret makes her debut - moving into the 21st century - as fresh and enchanting as ever… so be the first to re-discover Margaret the Medieval Queen of Scotland so advanced for her place in history..

Our all time favorite…brilliant and beautiful Margaret

SAYING GOOD BYE TO NORA EPHRON *(Volume 4)*
https://amzn.com/B015LFRP4C

Everyone loves Nora Ephron, right? Especially her divine recipes. Especially her clever movies. Especially her joie di vivre.

This quick and easy to read paper is a sweeping mini-bio of Nora that slides gracefully into her last six years on this earth, when no one knew what was in store for her.

As Frank Rich wrote in New York Magazine "What doesn't matter is whether we got to say good-bye or not. What does matter is that she was here for those she loved and those who loved her, and that now, while we were napping, she has gone."

Witty and clever Nora…a powerful writer bringing joy to all her readers

#EVERYTHING IS COPY

A treat is in store for her fans.

Exit Laughing…Nora Ephron's dramatic departure…and when we looked the other way, she left the room…

Nora is still with us…her humor and joie de vivre living on!

THE PEACOCK ROOM and WHISTLER'S MOTHER *(Volume 5)*
https://amzn.com/B017V4XSBU

A personalized look at the life and times of James Abbott McNeill Whistler…

During the course of his work for the art patron, Frederick R. Leyland, a Liverpool ship owner, the following transpired:

"That gave the excitable Whistler a clear field. Alone in the house, he more than touched up the room with a little gold paint. He let his imagination run wild with peacock feather designs on the ceiling, ornate peacocks in gilded paint on the shutters, and around the walls.

'Well, you know, I just painted on and on. I went on – without design or sketch – putting in every touch with such freedom…and the harmony blue and gold developing, you know, I forgot everything in my joy of it.'

And, most shockingly, he painted over the leather walls.

Now about those leather walls. The leather had been bought by Thomas Jekyll at great expense to Mr. Leyland. It had been part of the dowry of Catherine of Aragon who brought it from Spain. It was richly embossed and trimmed, and important in its own right.

Whistler had covered all the visible rich antique Spanish leather completely with a thick coat of peacock blue paint. "

DISCOVERING ALVIN A MAN OF MARK AND MYSTERY (Volume 6)
http://amzn.com/B018PN1V6U

> *"The photographic career of Alvin Langdon Coburn appears before our eyes like a brief time exposure through a fast lens."*
>
> *He was an amazing modern photographer working a century ahead of his time, inventing cutting edge techniques along the way…all in the first 24 years of his life. Then enjoy a full report of what came after that in the remaining 60 years. It's an engrossing and fresh story.*
>
> *Mrs. Marsh's paper explores the relationship between photography and fine art through the lens of the long forgotten photographer Alvin Langdon Coburn, who was born in 1882, with a nod along the way to the Spencer Art Reference Library and the cult of Freemasonry, and the current heralded fine art photographer Matthew Pillsbury.*

THE LAST EMPRESS MADAME CHIANG KAI-SHEK (Volume 7)
http://amzn.com/B01IKWLPA8

> *She had been glamorous. She had been sexy and compelling. She had dreams of ruling the world. Sometimes she was known as the Dragon Lady, in another life she was known as Soong Mei-ling, one of the three beautiful, rich and powerful Soong Sisters.*
>
> *She was Madame Chiang Kai-shek. ..*
>
> *Admirable…or notorious…moral or amoral…calculating and determined… charming and patriotic…Christian…all of those things, and more… Madame Chiang Kai-shek*

DAVID DOUGLAS DUNCAN PHOTOGRAPHER EXTRAORDINAIRE (Volume 8)

http://amzn.com/B01IUNNRG2

Happy Birthday to David Douglas Duncan! Celebrating his 100th birthday, still going strong, living in Castellaras, France, and enjoying worldwide recognition.

The accumulated vision of a matchless eye…from iconic wartime photos to intensely personal at-home images of Picasso at play and at work…much of Duncan's prolific body of work is archived and made available to the public through The Harry Ransom Center at the University of Texas at Austin thanks to the foresight and generosity of Stanley Marcus.

This '81 Club paper, first presented in 2005, still reverberates with vitality, as accurate and interesting today as it was then. Mr. Duncan's work is a living history of war and the nomad life.

MADAME CURIE as REIMAGINED by LAUREN REDNISS (Volume 9)
http://amzn.com/B01K5Z0XXI

The imaginative re-telling of the well known story of Marie and Pierre Curie, their passionate love, their passionate research, their brilliant discovery, blooms in the book Radioactive...Marie & Pierre Curie A Tale of Love and Fallout by Lauren Redniss.

Radioactivity had made the Curies immortal. Now it was killing them.

Early on in our story, we are seeing the lack of fear as Marie and Pierre work to discover radium...not being afraid to be close to it, nor touch it, and treating it like a pet that might be cuddled and kept by Marie's pillow...so, it must be assumed, they did not yet sense the danger of it.

Marie wrote: "Crystals of barium chloride containing radium are colorless, but when the proportion of radium becomes greater, they have a yellow color...after some hours, verging on orange, and sometimes a beautiful pink."

Again we see her fearless enjoyment of the beauties of radium.

"The flame spectrum of radium contains two beautiful red bands, one line in the blue-green, and two faint lines in the violet."

And later...in the spring of 1910 a flush appeared over Marie's cheeks. She pinned a flower to her dress. She had taken a lover.

But then the magic of X-ray in wartime...

No longer were doctors performing blind exploratory surgeries on already damaged bodies.

It's a breathtaking and important story.

Marie and Pierre Curie sleep today in Paris's splendid necropolis, the Pantheon.

Held in the Bibliotheque Nationale, the Curies' laboratory notebooks are still radioactive, setting Geiger counters clicking 100 years on.

CHARACTER EDUCATION PICTURE BOOKS for CHILDREN SERIES
Kindle Edition

These ebooks form a series of luminously illustrated children's stories, each with a timeless animal protagonist, a compelling geographic location, an important multicultural life skills message.

Each serious lesson is embedded in an exciting colorful adventurous story.

The stories are cleverly and skillfully written by published authors with a high level of literary talent and wit. They have been edited and proofed and re-proofed to the most exacting standards of accuracy in grammar, punctuation and fact checking. They have been reviewed…pre-publication…by teachers and librarians for relevance and the power of the message.

ALOHA POTTER!
http://amzn.com/B008LZ8JH2

> "You get the idea, don't you? 'Alakuma liked to tease Potter. That might have been okay, but the things 'Alakuma said made Potter feel sort of … bad. Bad about his size. Bad about his name.
> Bad about everything."

AMAZING MALLIKA
http://amzn.com/B008C9K7OK

> "Amazingly, marching had made Mallika feel better. Her anger had melted. 'I'll never get so angry again,' she promised. 'No matter what!' But that was before the langur monkeys laughed at her."

BAILEY'S BIRTHDAY
http://amzn.com/B0083LLTHQ

> "Early the next morning, a loud CLANG! from the street below woke him.
>
> Bailey sprang to the window. 'They're delivering my presents!' he said. But all he saw were garbage collectors emptying garbage cans into their big truck.
>
> 'Haven't been good enough yet,' he decided."

BASTET
http://amzn.com/B0083V6AGQ

> "But Bastet did not follow. She stopped outside the door. She sat. She thought. She remembered everything she and Sabah had heard about Tutankhamun's mask. The dazzling gold! The ebony eyes! The jeweled cobra! The brilliant inlays of lapis-lazuli and quartz and obsidian! And in her mind's eye she saw, staring up at Tutankhamun, two scrawny cats, one golden and one spotted. That was her dream, after all. Not just to see the mask, but to see it with Sabah. Together.
>
> How disloyal she had been to Sabah!"

BEA'S OWN GOOD
http://amzn.com/B0081VMGDC

> "When I awoke, I found myself in the bottom of Cati's bicycle basket. I crawled to the top to see what I could see. I was back in the bee-master's garden, and there was my hive only a few feet away! Even so, I was so cold that I could not fly to the hive.
>
> Suddenly there was the bee-master himself looking down on me.
>
> 'I will help you, my little friend,' he said."

CLARISSA
http://amzn.com/ B008WX9TOA

> *"Fiona and Tessy were always pushing Clarissa around. They nudged her away from the sweet patches of clover she found. They crowded her from the shade of the old oak tree. They shoved ahead of her at the feeding trough. But Clarissa never complained. It seemed to her that you had to be big and bossy like Fiona or beautiful like Tessy to get what you wanted. And she was neither.*
>
> *Clarissa was just a plain brown cow."*

EMILY BREAKS FREE
http://amzn.com/B0085RPUF0

> *"Emily looked at Cotton's stricken face and then at Spike's expectant one. She gobbled the biscuit down, but it didn't taste as good as she had thought it would. 'I declare!' cried Cotton.*
>
> *'I do believe the dogs in this town are the meanest ol' dogs I have ever had the misfortune to encounter!'"*

FEATHERS AT LAS FLORES
http://amzn.com/B008FRH7HY

> *"Then, who should show up but Julio himself.*
>
> *'What's going on here?' he asks.*
>
> *'Maybe you should ask Feathers,' says Angela. Everyone's eyes turn on me. I mean, I've learned my lesson. And I'm hoping everybody else has too. What am I supposed to say? Then it comes to me.*
>
> *'HAVA CUPPA COFFEE!' I squawk as loud as I can. It seems the only safe thing to say.*
>
> *Know what I mean?"*

FOLLOWING ISABELLA
http://amzn.com/B008257QNE

> "Then Isabella saw it – smoke boiling up from over the hill. A wildfire raged, sparked by the lightning. Without thinking, Isabella called out, 'Don't run! Follow me!' She turned to Pedro with panic in her eyes. Which way? 'Isabella,' he said, 'you must find the way home!'
> She thought quickly…
> Oh, what if she chose the wrong way?"

GUMBO GOES DOWNTOWN
http://amzn.com/B008HK4KH4

> "I fell asleep thinking about the dog with no home and thinking about my home and wondering if this might be the night an intruder came, with no watchdog there to warn Gus."

HANA'S YEAR
http://amzn.com/B008CXAPKW

> "How grateful Kenji and his grandmother were that Hana had saved the kimono cloth. Hana would always remember that day – how grandmother patted the top of her head and how Kenji bowed to her once again.
> 'O-saru-sama,' he said. 'Very honorable monkey.'"

INGER'S PROMISE
http://amzn.com/B008IVMGQ4

> "For the rest of the festival week, Inger was too embarrassed to talk to anyone.
> Every whisper, every giggle, every sideways glance – Inger was sure they were all aimed at him.
> How would he ever make up for the wedding-day disaster?"

JACKSON'S PLAN
http://amzn.com/B008CRBAUM

> "It hadn't been easy, but Jackson had stuck to his plan, and he had succeeded.
> He grinned a long froggy grin and returned to his dreams of dragonflies and beetles."

JOMO AND MATA
http://amzn.com/B008HLK1O4

> "An hour later, Jomo woke with a start. He caught a sharp scent that made his skin prickle. He raised his trunk in the air. Jomo was sure he could smell a lion nearby.
> Then he saw two gold eyes peering at him from the brush!"

KIKI AND THE CUCKOO
http://amzn.com/B008CADSUY

> "Suddenly the small door opened and someone was pulling Kiki gently out of the box. A woman said, 'How did a bird get caught in our cuckoo clock?' A girl stood beside her. 'It's a meadowlark,' the woman said, holding Kiki in her gloved hand.
> 'Let me see,' whispered the girl. 'Oh,' she sighed, 'are they all as pretty?'
> 'No,' thought Kiki."

KYLIE'S CONCERT
http://amzn.com/B008DY0M8A

> "As Kylie traveled along, the way grew strange and mysterious."

LUDMILA'S WAY
http://amzn.com/B008679S5W

> "My dear Babushkas," said Ludmila. "Our Pavel has had only bits of grass and a few bugs to eat today. Won't you share?"
>
> "Nyet," they said.
>
> "Babushkas, might this not be a chance for a new beginning? We could put the old way behind us! We could share and share alike! That is the best way, don't you agree? Pavel? Babushkas?"
>
> "Da!" said hungry Pavel, nodding hopefully at the Babushkas.

MOLLY'S MAGIC
http://amzn.com/B008GESVVW

> "'I can't believe we're so busy,' Mrs. O'Malley said. 'It's like magic!'
>
> 'Such a clever sign!' said a visitor. 'Why, that pig of yours is irresistible! I had to come and see your farm, and I'm glad I did. This tea is delicious!'
>
> 'Pig?' said Mrs. O'Malley, looking towards the sty. 'What pig?'"

PAPA PICCOLO
http://amzn.com/B008J9X1JG

> "When nighttime came to the canals and narrow streets of Venice and almost everyone went **inside** and turned on the lights, Piccolo went **out**.
>
> The dark was full of possibilities. Who knew what Piccolo might find inside that open window? Perhaps a shiny trinket, a dish of cream, or a pretty yellow canary?

PEQUENA THE BURRO
http://amzn.com/B008HLK4PK

> "From somewhere in the crowd, Pequena thought she heard a familiar voice. 'There is no such thing as only a burro.' 'Just a little more' – Senora Alvarez called. Pequena pressed on. The heat from the sun and the heat from the effort were nearly suffocating.
>
> And then Pequena felt the rope suddenly go slack."

PLATO'S JOURNEY
http://amzn.com/B0088TQZZE

> In this age of white lies and casual deceptions, Plato's story will make readers of all ages value the simple truth.

STANLEY'S "THIS IS THE LIFE!"
http://amzn.com/B008D6Q2J6

> "All day Stanley hid beneath a bridge. The early summer breeze smelled of lupines and clover. A grasshopper jumped from a dandelion onto Stanley's nose. Lying in the cool shade, Stanley thought about home. Then his nose twitched.
>
> **I know that smell**, Stanley thought. **Popcorn!** He could almost taste the butter and salt."

TESSA ON HER OWN
http://amzn.com/B008EEQ1AC

> "At first, Tessa could barely catch enough to keep herself from starving, but in time, she became an excellent hunter. Tessa felt proud to be a fox.
>
> 'Nobody can call me lazy now!' she said, carefully grooming her full russet tail."

THANK YOU, MEILING
http://amzn.com/B008HLK5VI

> "Song Hai's friend Go Ming runs to sit beside him. I see a wistful look flicker across Song Hai's face. He places his bun back on its wrapping, then tears it in half.
>
> 'Here Go Ming,' he says. 'Please share my snack. It's too much for me to eat alone.'"

TOAD IN TOWN
http://amzn.com/B008257T72

> "When toad awoke it was nearly dark. He rustled out of his leafy bed. Bright lights loomed up and rushed by with a roar. Then more. And more.
>
> 'Where AM I?' he cried. 'And how will I ever get back home?'
>
> All that night toad stayed in the dark, always looking for a familiar landmark, sniffing the air for the smell of the meadow, listening for the sound of the brook
>
> The next day and night were the same. And the next.
>
> There finally came a night when toad knew that his world had changed forever.
>
> Toad would have to make himself a new home in this new world."

Joan's Book Collections

Contact Joan Marsh at email: joanmarsh@aol.com

JOAN'S THRILLING READING LIVING VICARIOUSLY Series
https://www.ebooksbyjoanmarsh.com/

JOAN'S CHARACTER EDUCATION PICTURE BOOKS
for CHILDREN Series
https://www.childrensebooksbyjoan.com

JOAN'S AMAZON AUTHOR PAGE
https://www.amazon.com/author/joanmarsh

JOAN'S FACEBOOK PAGE and TWITTER ACCOUNT
https://www.facebook.com/people/Joan-K-Marsh/100011486057355
https://www.twitter.com/@joanmarsh3

www.ingramcontent.com/pod-product-compliance
Lightning Source LLC
Chambersburg PA
CBHW041209180526
45172CB00006B/1218